101 Super Cute
THiNGS
TO DRAW

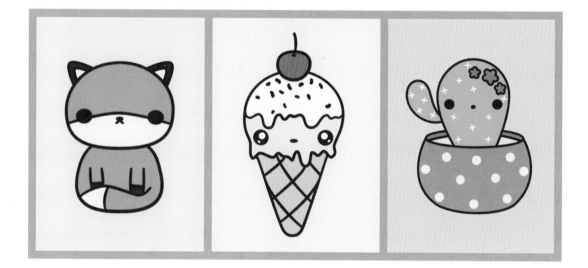

Lauren Bergstrom

Quarto.com

© 2022 Quarto Publishing Group USA Inc.
Text and illustrations © 2022 Lauren Bergstrom

First published in 2022 by Walter Foster Publishing, an imprint of The Quarto Group.
100 Cummings Center, Suite 265D, Beverly, MA 01915, USA.
T (978) 282-9590 **F** (978) 283-2742

Walter Foster Publishing titles are also available at discount for retail, wholesale, promotional, and bulk purchase. For details, contact the Special Sales Manager by email at specialsales@quarto.com or by mail at The Quarto Group, Attn: Special Sales Manager, 100 Cummings Center, Suite 265D, Beverly, MA 01915, USA.

ISBN: 978-0-7603-7501-3

Digital edition published in 2022
eISBN: 978-0-7603-7502-0

Printed in China
10 9 8 7 6 5

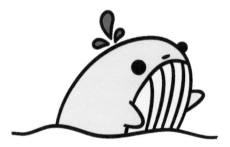

Table of Contents

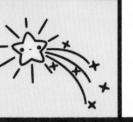
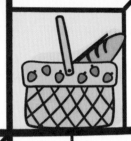
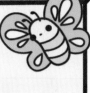

INTRODUCTION

Create your very own little kawaii world with *101 Super Cute Things to Draw!* Take a walk in a tiny forest of your own creation, or fly among rainbows, clouds, and shooting stars. Meet creatures both real and imagined, but all brimming with cuteness and personality. Discover shelves filled with happy books and plants and all sorts of different objects, or feast your eyes on sweet and savory treats too cute to eat!

Doodling can be a fun and relaxing activity for all ages, and this book will show you how. There are drawing lessons for 101 adorable things to inspire your imagination. Use these projects as a starting point for your own creativity, and don't worry about being perfect. Just have fun and let your own style shine through!

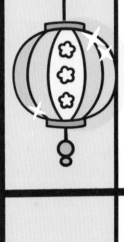

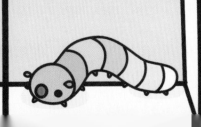
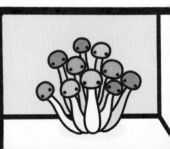

TOOLS & MATERIALS

You don't need anything special to start drawing. Choose supplies that you're comfortable with and enjoy using. Here are some suggestions to get you started:

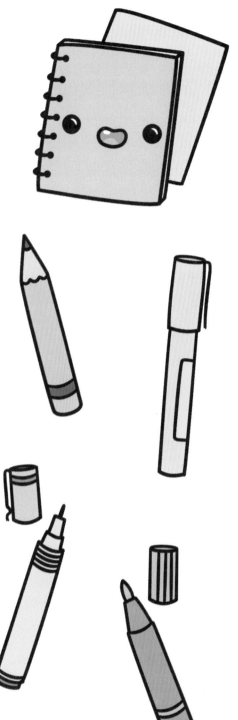

Paper
Notebooks and sketchbooks are great for taking your doodles anywhere you go. If you're using markers, choose thicker paper so that the colors don't bleed through.

Gel Pens
Gel pens can be used to draw outlines and fill in small areas of color. They come in many colors, including neon, white, and metallic, which can be used to add highlights and sparkles.

Colored Pencils
Use these to color in your drawings. You can layer different colors to make them more interesting. Good quality colored pencils have a smooth feel, and will create more vibrant colors.

Fineliner Pens
Fineliner pens with pigment ink have very fine tips, and are good for drawing thin outlines and little details.

Brush Markers
Brush markers have a soft tip that looks a bit like a paintbrush. They can be used to add color to your drawings, and you can blend different colors together to make interesting effects.

DRAWING TIPS & TECHNIQUES

Everybody has their own unique drawing style, so feel free to experiment and try different things. You can even draw the same thing in different ways to see which one you like best. Here are some different things you could try:

Using Different Outlines

You don't have to be limited to using black for outlines. Try brown, blue, red, or green instead. You can also experiment with thicker or thinner outlines to see which you prefer.

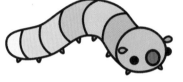 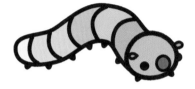

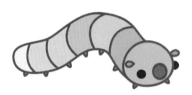 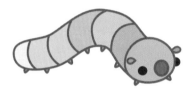

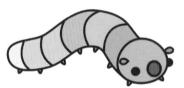 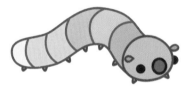

Mixing Materials & Tools

Try adding colored pencil shading on top of brush markers (like the octopus on the left) or gel pen details on top of colored pencil (like the octopus on the right). Different materials can create very different effects!

Adding Paint

Watercolor and gouache paints can be used to fill in larger areas of color, or to add details. Gouache is particularly good for adding lighter details on top of a darker color.

Experimenting with Faces

Faces add character and personality to your drawings, so play around with different facial expressions. Here is a chart with many different faces to try!

USING COLOR

The color wheel is a visual way to show basic color theory. Understanding the relationships between colors will help you choose which colors to use to bring your drawings to life.

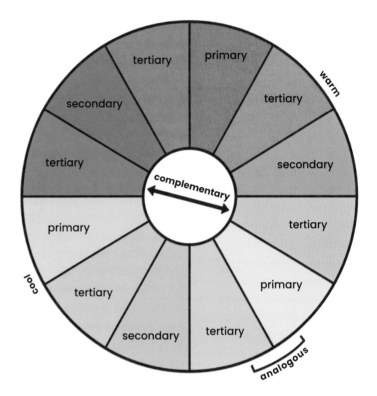

Primary Colors
Red, yellow, and blue are primary colors. They can't be created by mixing other colors.

Secondary Colors
Orange, green, and purple are secondary colors. They are made by mixing two primary colors together.

Tertiary Colors
Mix a primary and a secondary color together and you have a tertiary color! These include red-orange, yellow-orange, yellow-green, blue-green, blue-purple, and red-purple.

Color Temperature
Red, orange, and yellow are "warm" colors. Blue, green, and purple are "cool" colors.

Complementary Colors
Colors directly across from each other on the color wheel are called complementary colors, such as red and green or orange and blue. These colors make each other stand out, and look bright and bold together.

Analogous Colors
Colors next to each other on the color wheel are called analogous colors, such as green and blue-green, or yellow and yellow-green. These colors look harmonious together and can be used to create gradients of color.

CREATING TEXTURES & PATTERNS

You can use textures and patterns to make your drawings more interesting. Try experimenting with different kinds of marks and strokes. Here are some examples to get you started.

Hatching
Make lots of lines in the same direction. The lines can be long or short, close together or far apart.

Crosshatching
Make lots of lines in opposite directions. Like hatching, the lines can be long or short, close together or far apart.

Scumbling
Fill in areas of color by scribbling in a small, circular motion. Denser scribbles will create darker colors.

Stippling
Fill in an area with lots of little dots. Make the dots closer together for darker areas.

Gradating
Shade an area from dark to light by adding more layers of color to the darker area.

Blending
Blend two colors together by making two gradated areas that overlap in the middle.

There are endless possibilities when it comes to adding cute patterns. Here are a few ideas.

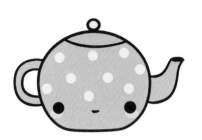 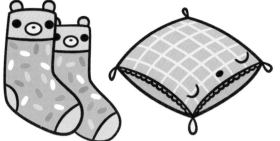

Polka dots

Thick stripes

Raindrops

Checkers

Flowers

Wavy lines

Thin stripes

Sprinkles

Grid

EVERYDAY OBJECTS

1. Books

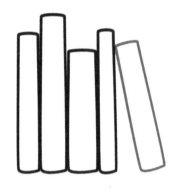

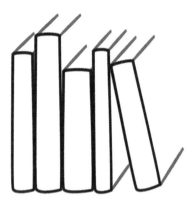

1. Start with a few long rectangles standing up next to one another.

2. Draw one more rectangle leaning on the others.

3. Add some lines at an angle for the tops and bottoms of the books.

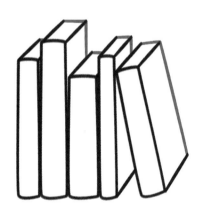

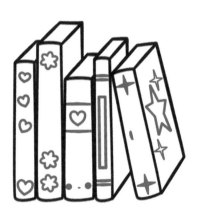

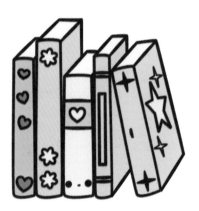

4. Draw the back edges of the books.

5. Add some cute little details, such as flowers, hearts, stars, and faces.

6. Color in your books with off-white for the pages and some nice colors on the covers.

2. Vase

1. Start with a small, squashed oval for the top of the vase.

2. Draw the rest of the vase in any shape you like.

3. Draw a few randomly spaced circles in different sizes above the vase.

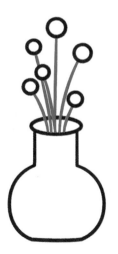

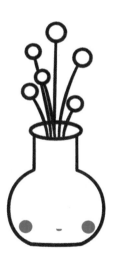

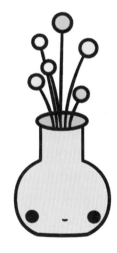

4. Add some curved lines for stems.

5. Decorate your vase with a cute little face.

6. Color in your vase and flowers.

3. Teacup

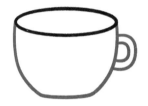

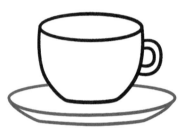

1. Start with a squashed oval shape for the top of the cup.

2. Draw in the rest of the teacup and add two small curves on the side for the handle.

3. Add a saucer by drawing another squashed oval with a curved line underneath.

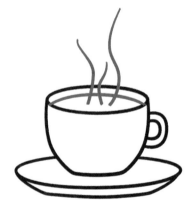

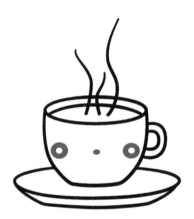

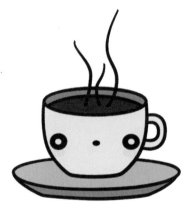

4. Draw a line near the top for the liquid, and add some squiggly lines for steam.

5. Add a cute face onto the front of the teacup.

6. Color in your teacup and saucer, adding some light pink blush under the eyes.

4. Teapot

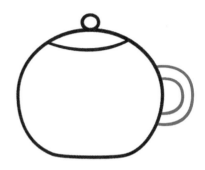

1. Start with a rounded blob shape.

2. Add a lid by drawing a curved line on the blob, and a small circle on top.

3. Draw two curved lines on the side for the handle.

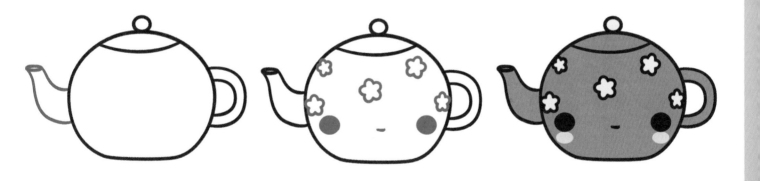

4. Give your teapot a spout.

5. Add a cute flower pattern and face onto the body of the teapot.

6. Color in your teapot, adding some light pink blush under the eyes.

5. Cookie Jar

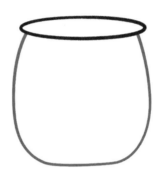

1. Start with a squashed oval shape for the lid.

2. Draw the rest of the cookie jar under the lid.

3. Add a small circle on top.

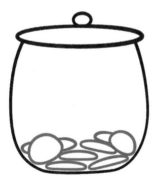

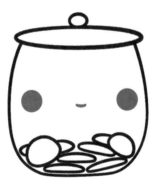

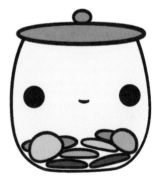

4. Draw some cookies at the bottom of the jar.

5. Add a cute face onto the front of the jar.

6. Color in your cookie jar, using a light color for the glass.

6. Milk Carton

1. Start with a fat rectangle shape for the front of the carton.

2. Add two angled lines and one straight line on the side.

3. Draw a roof shape for the top of the milk carton.

4. Add a small tab on top.

5. Decorate the carton with a "milk" label, polka dots, and a cute face.

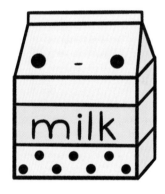

6. Color in your milk carton.

7. Coffee Cup

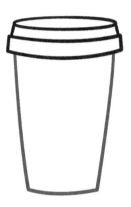

1. Start with a small squashed oval for the top of the lid.

2. Draw the rim of the lid just below the oval.

3. Add a cup shape below the lid.

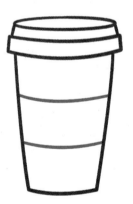

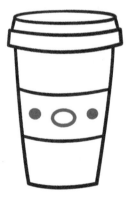

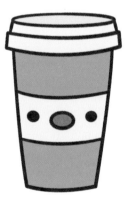

4. Draw two curved lines for the cup sleeve.

5. Add a cute nose and eyes.

6. Color in your coffee cup.

8. Pillow

1. Start by drawing a squashed diamond shape with curved edges.

2. Add two curved lines near the bottom for the pillow edges.

3. Draw a little tassel at each corner of the pillow.

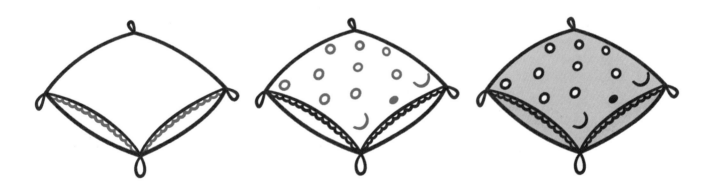

4. Add some frills along the front edges.

5. Draw some polka dots and a sleepy face on top.

6. Color in your pillow.

9. Socks

1. Start with one sock shape.

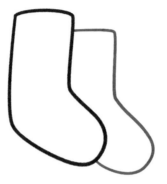

2. Draw another sock shape behind the first one.

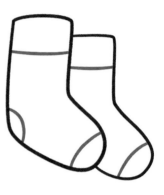

3. Add some ribbing at the top of the socks, and draw curved lines at the toes and heels.

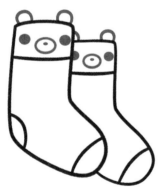

4. Add bear faces and ears on top!

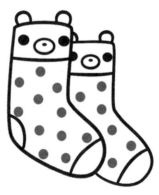

5. Decorate the socks with cute polka dots.

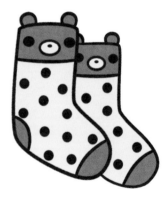

6. Color in your socks, using a darker color for the toes, heels, and ribbing.

10. Cozy Hat

1. Start by drawing a modified rectangle shape for the brim of the hat.

2. Draw a dome shape on top of the brim.

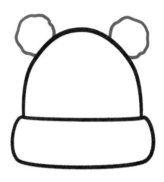

3. Add two fluffy pom-poms on top.

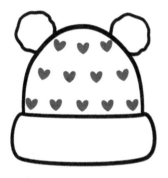

4. Decorate with cute little hearts.

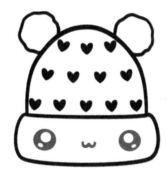

5. Add a face to the brim.

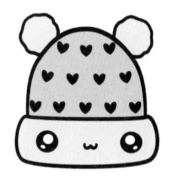

6. Color in your warm and cozy-looking hat.

11. Headphones

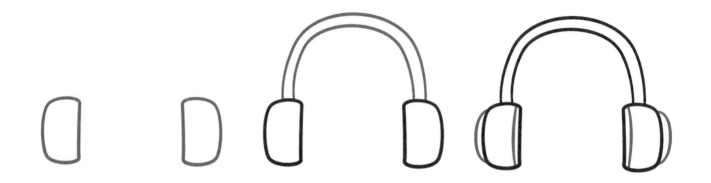

1. Start with two rounded rectangle-like shapes for the ear cups.

2. Add two curved lines on top for the headband.

3. Draw some details on the ear cups.

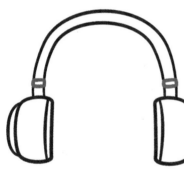
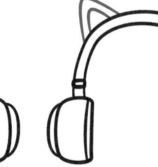
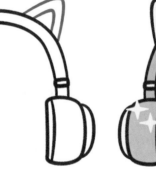
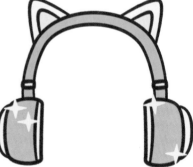

4. Add some more little details on the headband.

5. Draw a pair of cute cat ears on top.

6. Color in your headphones using pink and purple.

12. Backpack

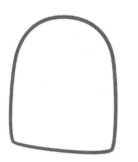

1. Start by drawing the front of the backpack.

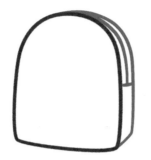

2. Draw the side of the backpack and a line for the zipper.

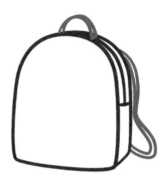

3. Add a handle on top and a shoulder strap at the back.

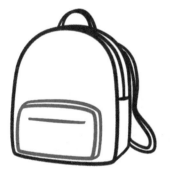

4. Draw a rounded rectangle for the front pocket, with a straight line for the zipper.

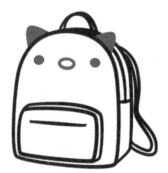

5. Add some ears and a cute little face.

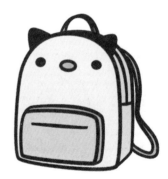

6. Color in your backpack.

13. Camera

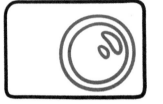

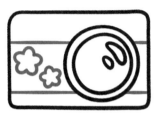

1. Start by drawing a rectangle with rounded corners.

2. Draw two circles for the lens with small blob shapes for reflections.

3. Add two straight lines on the body of the camera and two flower shapes for decoration.

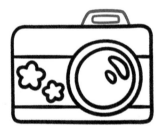

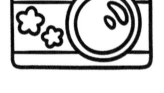

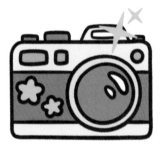

4. Draw a little light above the lens.

5. Add in more buttons and sensors.

6. Color in your camera.

14. Picnic Basket

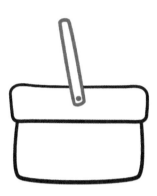

1. Start by drawing a rounded rectangle with an open top.

2. Draw a rough rectangle shape for the rim, leaving a small space open for the handle.

3. Draw a handle in the middle of the basket.

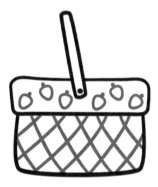

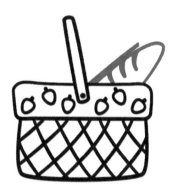

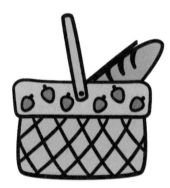

4. Add some lines onto the basket for texture and strawberry shapes for decoration.

5. Draw a straight line for a lid, with a loaf of bread sticking out.

6. Color in your picnic basket and bread.

15. Umbrella

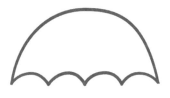

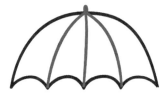

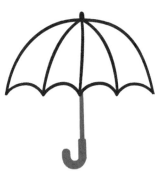

1. Start with a dome shape with a scalloped edge on the bottom.

2. Draw a small line on top of the dome, and some curved lines to divide it into segments.

3. Add a straight line under the umbrella, with a thicker "J"-shaped handle.

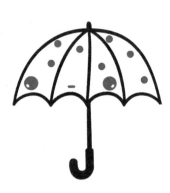

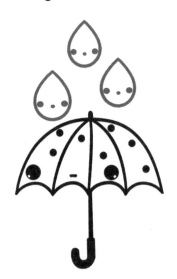

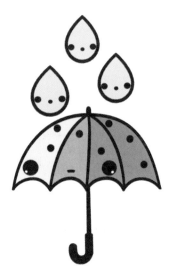

4. Draw a polka-dot pattern and a face.

5. Add three big raindrops!

6. Color in your umbrella, using a different color for each segment to make it more interesting.

16. Birdhouse

1. Start by drawing a curved triangle roof.

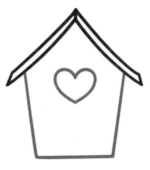

2. Add the body of the birdhouse and draw a heart-shaped hole on the front.

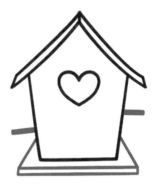

3. Add the base of the birdhouse and some pegs on the sides.

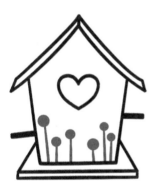

4. Decorate with cute flowers and stems.

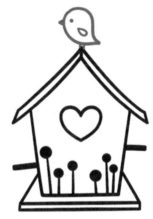

5. Draw a little bird perched on the roof.

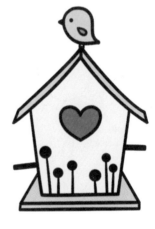

6. Color in your birdhouse, making sure the heart-shaped hole is a darker color.

17. Balloons

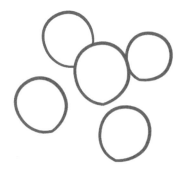

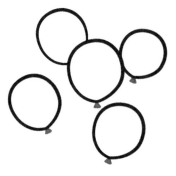

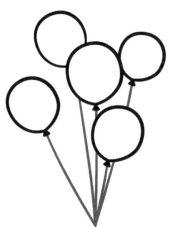

1. Start by drawing a few ovals in slightly different sizes.

2. Draw a tiny triangle at the bottom of each oval.

3. Add some straight lines for the balloon strings.

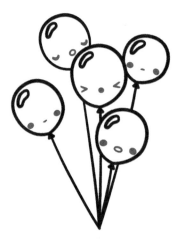

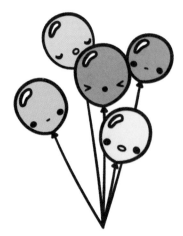

4. Draw a blob-shaped reflection on the top, left side of each balloon.

5. Add a cute face to each balloon! Try experimenting with different expressions.

6. Color your balloons with different bright colors.

18. Lantern

1. Start with a fat oval shape for the body of the lantern.

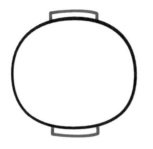

2. Draw small rectangle-like shapes on the top and bottom of the oval.

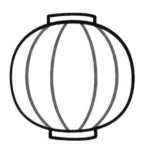

3. Add some curved lines to divide the lantern into segments.

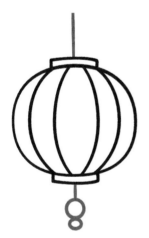

4. Draw a straight line passing through the middle of the lantern.

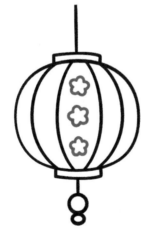

5. Decorate the front of the lantern.

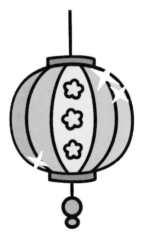

6. Color in your lantern. Use a different color for each segment to make it more interesting.

19. Fairy House

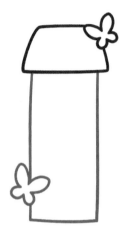

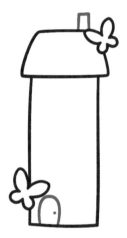

1. Start by drawing a rounded trapezoid shape for the roof, with a butterfly in the corner.

2. Draw a tall rectangle house underneath, with another butterfly near the bottom.

3. Add a small chimney on top, and a cute little rounded door at the bottom.

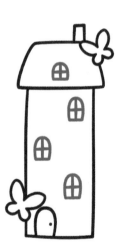

4. Draw a few arched windows on the wall and roof.

5. Draw some vines and leaves growing up the wall.

6. Color in your fairy house.

20. Terrarium

1. Start with a tall triangle for the front.

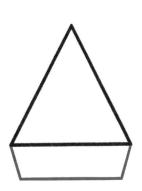

2. Draw a flat base underneath the triangle.

3. Add some angled lines on the sides, a circle at the tip, and a straight line on top.

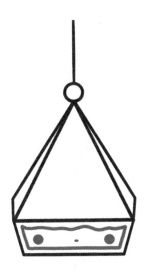

4. Draw the soil at the bottom with a tiny face.

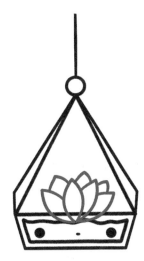

5. Draw a succulent inside the terrarium.

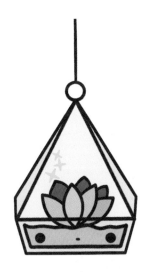

6. Color the plant green and the terrarium glass with a light blue color.

FOOD

21. Bubble Tea

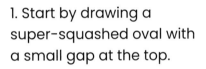

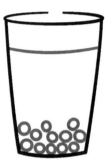

1. Start by drawing a super-squashed oval with a small gap at the top.

2. Add in the rest of the bubble tea cup underneath the oval.

3. Use small circles at the bottom of the cup for the tapioca balls, and add a curved line near the top.

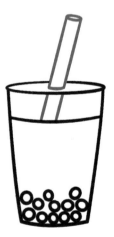

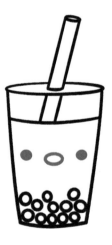

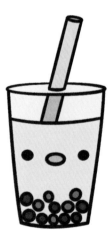

4. Add some straight lines for the straw, with a tiny oval at the top.

5. Draw a cute face on the front of the cup.

6. Color in your bubble tea.

22. Ice Cream

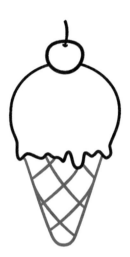

1. Start with a circle and stem for the cherry on top.

2. Draw a blob of melting ice cream underneath the cherry.

3. Add a rounded "V" shape under the ice cream with some lines to give it a waffle cone texture.

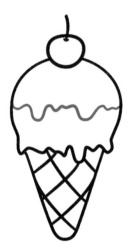

4. Draw a squiggly line in the middle of the scoop of ice cream.

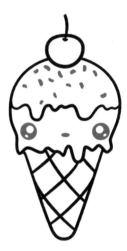

5. Add some small lines for the sprinkles on top, and draw a face in the middle.

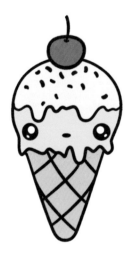

6. Color in your ice cream!

23. Waffles

1. Start by drawing a blob shape with a squiggly bottom. This could be a pat of butter, whipped cream, or ice cream!

2. Add in a squashed diamond shape with rounded corners.

3. Draw lines under the diamond for the sides of the waffle.

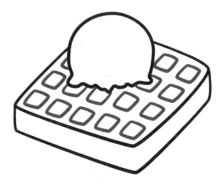

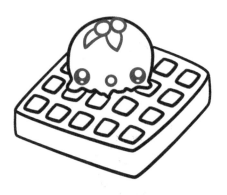

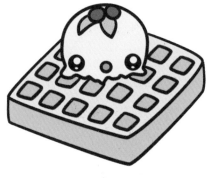

4. Add a grid of small squares on top of the waffle.

5. Draw a face and add some berries and mint leaves on top.

6. Color in your waffle. Yum!

24. Stack of Pancakes

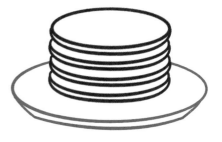

1. Start by drawing a squashed oval with a curved line underneath for the top pancake.

2. Add to the stack by drawing more curved lines under the first pancake.

3. Draw a bigger squashed oval and curved line underneath for the plate.

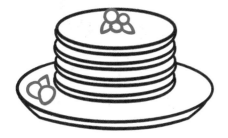

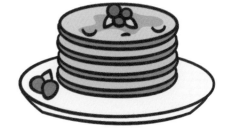

4. Garnish the pancakes and plate with berries.

5. Add a sleepy little face on top.

6. Color in your stack of pancakes.

25. Cinnamon Bun

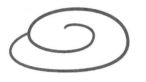

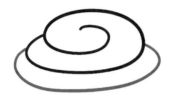

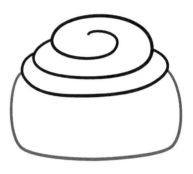

1. Start by drawing a spiral shape for the top of the bun.

2. Add a curved line underneath the spiral.

3. Draw in the rest of the cinnamon bun.

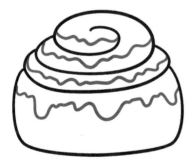

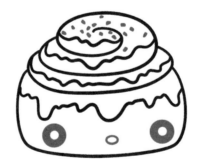

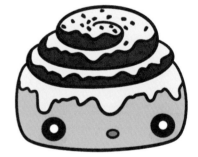

4. Add some squiggly lines on top for icing.

5. Draw a cute face and sprinkle little spots for nuts on top.

6. Color in your ooey gooey cinnamon bun.

26. Donut

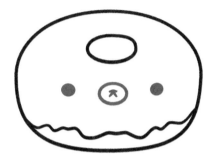

1. Start by drawing a rounded blob shape.

2. Add a small oval donut hole near the top and a squiggly line of icing near the bottom.

3. Draw two eyes and a small snout in the middle of the donut.

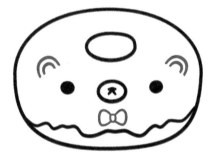

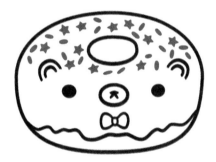

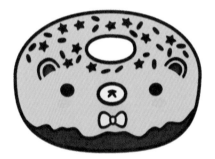

4. Add two bear ears and a cute little bow tie.

5. Draw some sprinkles and stars on top of the donut.

6. Color in your donut, adding some pink blush under the eyes.

27. Pie

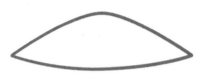

1. Start by drawing a wide hill shape for the top of the pie.

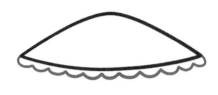

2. Add a scalloped edge along the bottom.

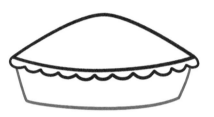

3. Draw the pie tin underneath the crust.

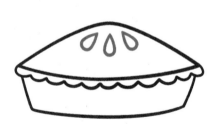

4. Add three teardrop shapes at the top of the pie.

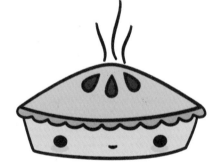

5. Draw a cute little face and some squiggly lines for steam.

6. Color in your pie.

38

28. Slice of Cake

1. Start by drawing a rectangle with slightly rounded edges.

2. Draw a blob of whipped cream hovering above the rectangle.

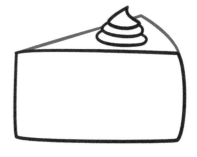

3. Add two angled lines to form a triangle shape on top of the slice.

4. Draw two slightly squiggly lines in the middle of the cake to indicate the layers.

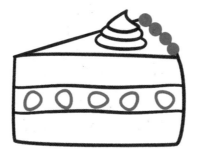

5. Add some strawberries in the middle of the cake and chocolate circles along the top edge.

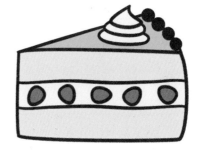

6. Color in your slice of cake.

29. Cupcake

1. Start by drawing the cherry on top.

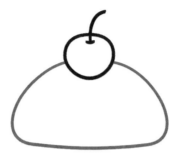

2. Add a dome shape under the cherry for the frosting.

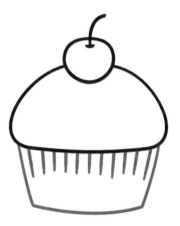

3. Draw in the cupcake liner with some vertical lines for texture.

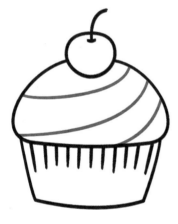

4. Add three swirly lines on the frosting.

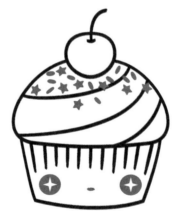

5. Draw some sprinkles on top and a cute face on the front.

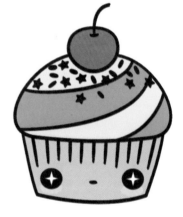

6. Color in your cupcake, adding some light pink blush under the eyes.

30. Croissant

1. Start by drawing the middle segment of the croissant.

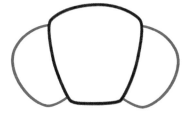

2. Add a blob shape on either side.

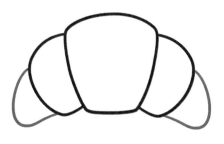

3. Draw in ends, making them slightly pointed and curved.

4. Add some sliced almonds on top and a squiggly line near the bottom.

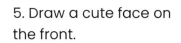

5. Draw a cute face on the front.

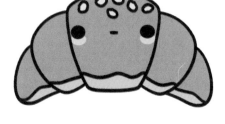

6. Color in your croissant, adding some light pink blush under the eyes.

31. Loaf of Bread

1. Start by drawing a bread slice shape.

2. Add three lines at an angle to create the top and side of the loaf.

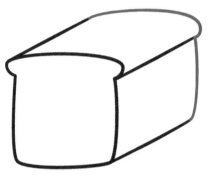

3. Draw the back edge of the bread loaf, using a similar shape to the front.

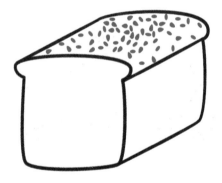

4. Add lots of seeds on top of the loaf.

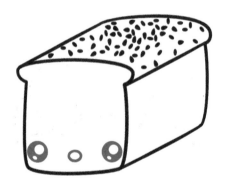

5. Draw a cute face on the front.

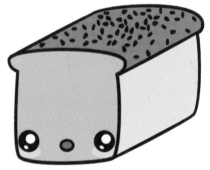

6. Color in your bread, adding some light pink blush under the eyes.

32. Bacon & Eggs

1. Start with a wavy strip of bacon.

2. Add another piece of bacon just below the first one.

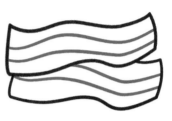

3. Draw two wavy lines on each piece of bacon.

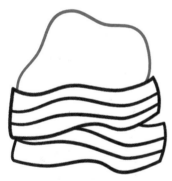

4. Add a blob shape sticking out from behind the bacon.

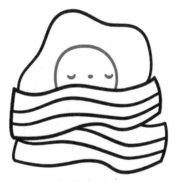

5. Draw part of a circle for the yolk and add a cute sleepy face in the middle.

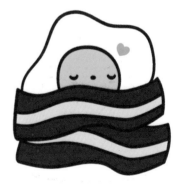

6. Color in your bacon and eggs, adding a tiny heart above the egg yolk.

33. Pizza Slice

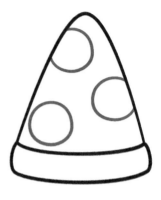

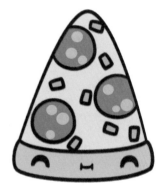

1. Start by drawing a thin rectangle with curved edges for the crust.

2. Add a cone shape on top of the crust.

3. Draw three circles for the pepperoni.

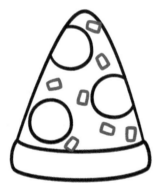

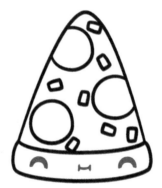

4. Sprinkle some small rectangles around the pepperoni.

5. Draw a happy face on the pizza crust.

6. Color in your pizza slice, adding a few lighter pink spots on each piece of pepperoni.

34. Taco

1. Start by drawing a semi-circle at a slight angle.

2. Add some squiggly lines along the edge for the filling.

3. Draw in the bottom and back edge of the taco shell.

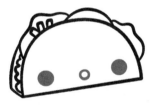

4. Add an adorable little face on the front.

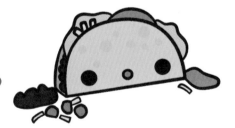

5. Draw a few little spills around the outside of the taco.

6. Color in your taco, adding some darker spots on the taco shell for texture.

35. Burger

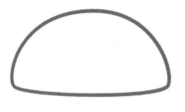

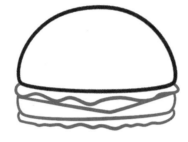

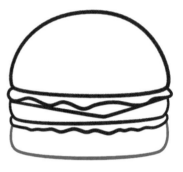

1. Start with a dome shape for the top of the burger bun.

2. Add some fillings, such as lettuce, cheese, a patty, and sauce.

3. Draw the bottom burger bun.

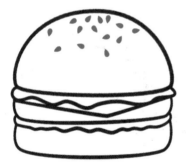

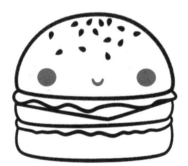

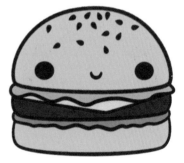

4. Add some sesame seeds on top.

5. Draw a happy face on the front.

6. Color in your burger.

36. Avocado

1. Start by drawing a pear shape.

2. Draw another pear shape slightly behind the first one.

3. Add an outer edge on each half of the avocado.

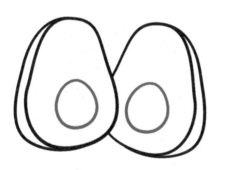

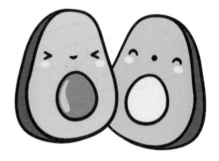

4. Draw an egg shape in the middle of each avocado half.

5. Add a cute face above each egg shape.

6. Color in your avocado, adding pink blush under the eyes and a light blob on the side of the brown avocado pit.

37. Sushi Roll

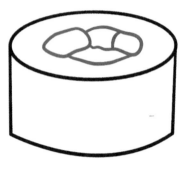

1. Start with a squashed oval shape.

2. Add in the sides and bottom of the sushi roll.

3. Draw some blob shapes in the middle of the oval.

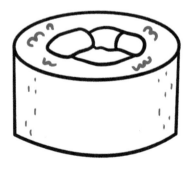

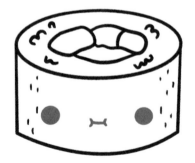

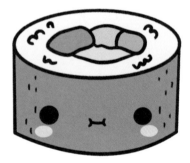

4. Add some squiggles for the rice texture, and tiny vertical lines on the seaweed.

5. Draw a cute face on the front of the sushi.

6. Color in your sushi roll, adding light pink blush under the eyes.

38. Nigiri Sushi

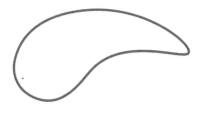

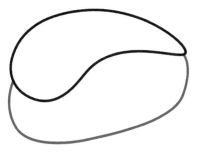

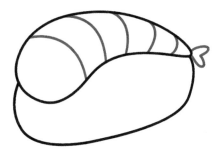

1. Start by drawing a curved blob shape for the shrimp's body.

2. Add a ball of rice underneath the shrimp.

3. Give the shrimp some stripes and a heart-shaped tail.

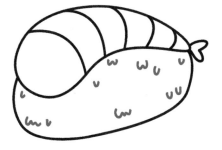

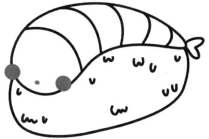

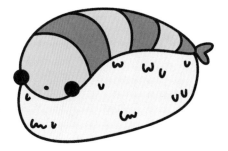

4. Add some squiggly lines onto the rice for texture.

5. Give the shrimp two big eyes and a dot for a mouth.

6. Color in your sushi, using alternating light and dark stripes on the shrimp.

39. Bowl of Noodles

1. Start with a squashed oval shape for the top of the bowl.

2. Draw a slightly smaller oval inside, and a curved line underneath.

3. Add some toppings, including mushrooms and boiled eggs.

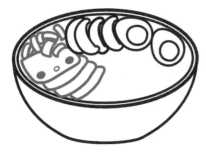

4. Draw slices of meat and chopped green onions for additional toppings.

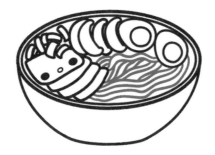

5. Fill the rest of the bowl with wavy lines for the noodles.

6. Color in your bowl of noodles.

40. Steamed Dumplings

1. Start with a squashed oval shape.

2. Add in the sides and bottom of the steamer basket.

3. Draw three little blob-shaped dumplings inside the basket.

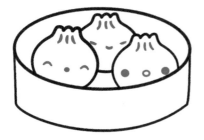

4. Add some creases at the top of each dumpling and give each one a face.

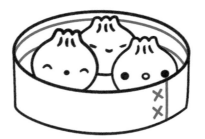

5. Draw some details onto the steamer basket.

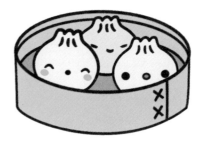

6. Color in your steamed dumplings, adding light pink blush under the eyes.

41. Takoyaki (Octopus Balls)

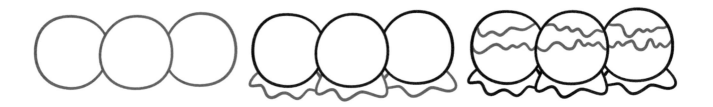

1. Start by drawing three circles slightly overlapping each other.

2. Draw a wavy line underneath each circle.

3. Add two squiggly lines of sauce near the top of each circle.

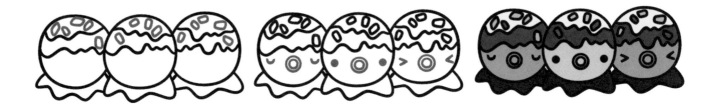

4. Sprinkle some garnish on top of the takoyaki.

5. Draw a big circle mouth and some eyes onto each ball.

6. Color in your takoyaki.

42. Onigiri (Rice Ball)

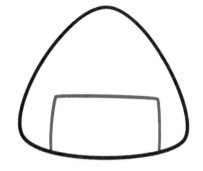

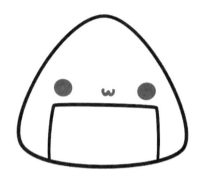

1. Start by drawing a fat, rounded triangle.

2. Add a rectangle near the bottom of the triangle.

3. Draw a "w" shape for the mouth and two big dots for eyes just above the rectangle.

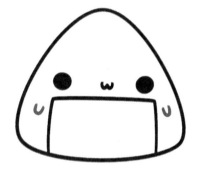

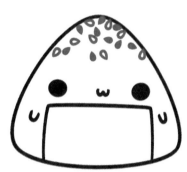

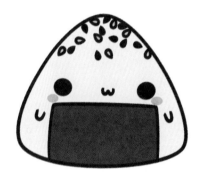

4. Give your rice ball two tiny arms.

5. Sprinkle some sesame seeds on top.

6. Color in your onigiri, adding some light pink blush under the eyes.

43. Dango

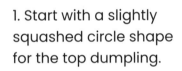

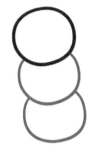

1. Start with a slightly squashed circle shape for the top dumpling.

2. Add two more balls underneath the first circle.

3. Draw a straight line passing through all three dumplings.

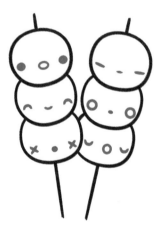

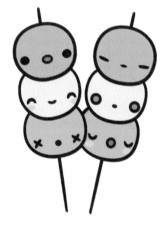

4. Repeat steps 1 to 3 to draw a second skewer.

5. Draw a cute face onto each ball.
Try experimenting with different facial expressions.

6. Color in your dango, adding light pink blush under some of the eyes.

44. Toaster Pastry

1. Start by drawing a rectangle with rounded corners.

2. Add a squiggly rectangle inside for the icing.

3. Draw small, straight lines all along the edges of the pastry.

4. Add some sprinkles on top of the icing.

5. Draw a little face near the bottom with sparkly eyes and a sprinkle-shaped mouth.

6. Color in your toaster pastry with any color frosting you'd like.

45. Caramel Apple

1. Start by drawing a slightly squashed circle for the apple.

2. Add a caramel coating around the outside of the apple.

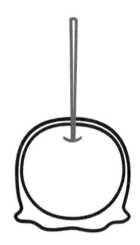

3. Draw a stick in the middle, and a small, curved line at the bottom end of the stick.

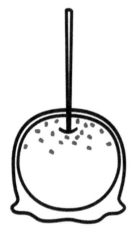

4. Sprinkle some nuts on top.

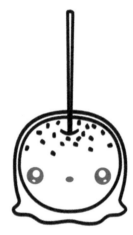

5. Draw a face with shiny eyes.

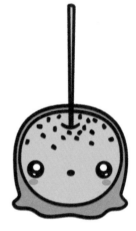

6. Color in your caramel apple, adding some pink blush under the eyes.

46. Pumpkin

1. Start with a tall oval shape.

2. Add a segment on either side of the middle oval.

3. Draw one more segment on each side of the pumpkin.

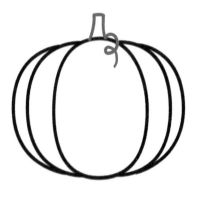

4. Add a little stalk and a curly vine on top.

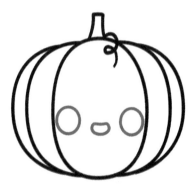

5. Give the pumpkin two big eyes and a mouth.

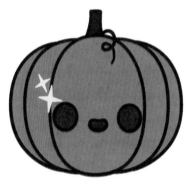

6. Color in your pumpkin, adding some sparkles above one of the eyes.

47. Watermelon Slice

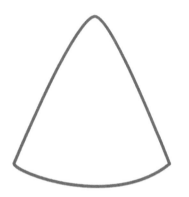

1. Start by drawing a triangle with a curved bottom edge and rounded top corner.

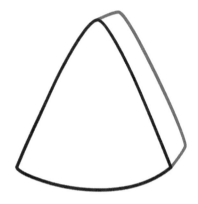

2. Add another line along the right edge of the triangle.

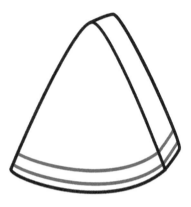

3. Draw two curved lines near the bottom of the watermelon slice to create the rind and peel.

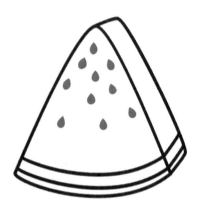

4. Add some seeds on the front of the slice.

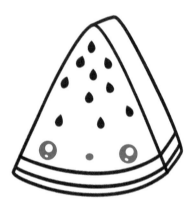

5. Give the watermelon a cute face with big eyes.

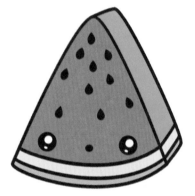

6. Color in your watermelon slice.

48. Pineapple

1. Start by drawing a rectangle with very round corners.

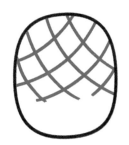

2. Add some crisscross lines onto the top two-thirds of the pineapple's body.

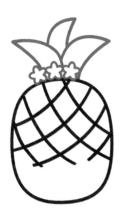

3. Draw three little flowers and three leaves on top of the pineapple.

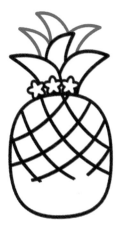

4. Add three more smaller leaves on top.

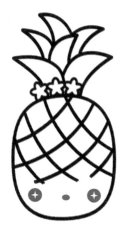

5. Draw a cute face near the bottom of the pineapple.

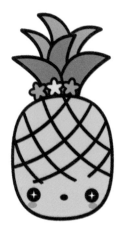

6. Color in your pineapple, adding some pink blush under the eyes.

49. Cherries

1. Start by drawing one cherry shape.

2. Draw another cherry slightly behind the first one.

3. Add a stem to each cherry, joined at the top.

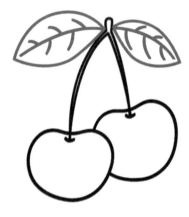

4. Draw two leaves at the top of the stems.

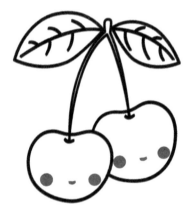

5. Give each cherry a cute face.

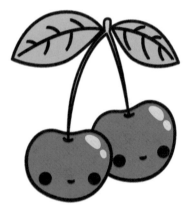

6. Color in your cherries, adding some lighter-colored blob shapes to the top-right of each cherry to show that they're shiny.

50. Chocolate Strawberry

1. Start by drawing a rounded shape that's a mix between a circle and a heart.

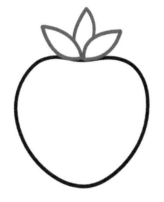

2. Draw three leaves on top of the strawberry.

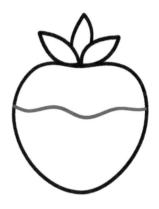

3. Add a wavy line for the chocolate.

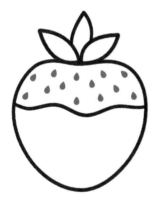

4. Draw some small seeds above the wavy line.

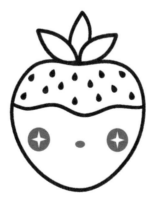

5. Add a face near the middle of the strawberry.

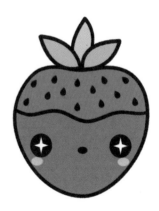

6. Color in your strawberry, adding some light pink blush under the eyes.

NATURE

51. Amanita Mushroom

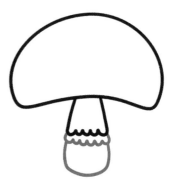

1. Start with a blob shape for the mushroom cap.

2. Draw a short stalk with a frilly bottom.

3. After drawing another frill, add the rest of the stalk with a rounded bottom.

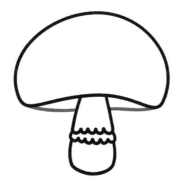

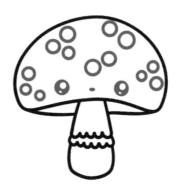

4. Draw a curved line for the back edge of the mushroom.

5. Add some spots and a cute face.

6. Color in your mushroom.

52. Beech Mushrooms

1. Start with a small, squashed circle shape for the mushroom cap.

2. Add a long stalk with a wide rounded bottom.

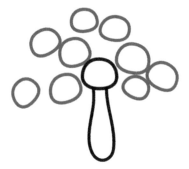

3. Draw more small mushroom caps, randomly spaced around the first mushroom.

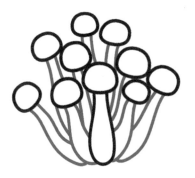

4. Give each mushroom a stalk, making them all meet together at the bottom.

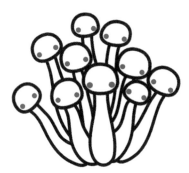

5. Draw two little eyes on each mushroom cap.

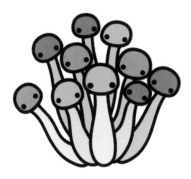

6. Color in your mushrooms!

53. Bunch of Flowers

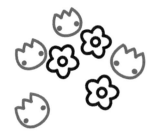

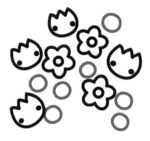

1. Start by drawing three small flowers with circles in the middle.

2. Draw some little tulips with small dots for eyes.

3. Add a few small circles in between the other flowers.

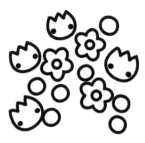

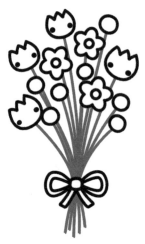

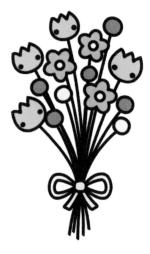

4. Draw a big bow underneath the flowers, leaving some space for the stems.

5. Add a stem to each flower, making the stems meet in the middle of the bow.

6. Add some pretty colors to your bunch of flowers.

54. Jade Plant

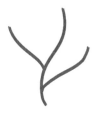

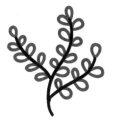

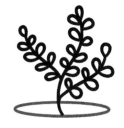

1. Start by drawing a main stem with two side stems.

2. Draw small, rounded leaves along each stem.

3. Add a squashed oval at the base of the main stem.

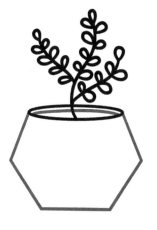

4. Draw the rest of the plant pot, and add a curved line near the top for the soil.

5. Give the plant pot two eyes and a mouth.

6. Color in your jade plant and plant pot!

55. Cactus

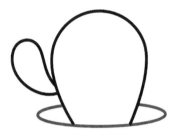

1. Start by drawing a big, curved line for the main part of the cactus.

2. Draw a big arm on the side of the cactus.

3. Add a squashed oval shape for the top of the pot.

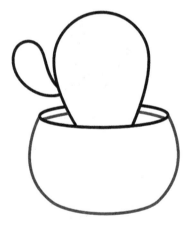

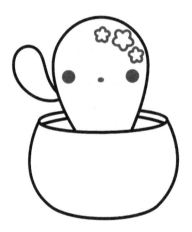

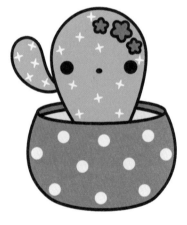

4. Draw in the rest of the pot, and add a curved line for the soil.

5. Give the cactus a face and some flowers on its head.

6. Color in your cactus, adding some white cross shapes for the spikes.

56. Bunny Succulent

1. Start by drawing three little mounds.

2. Draw two long ears on top of each mound.

3. Add a squiggly line near the bottom of each mound.

4. Draw two curved lines for the plant pot.

5. Give each bunny two little eyes.

6. Color in your bunny succulent, decorating the pot with colored polka dots.

57. Pancake Plant

1. Start by drawing a few small circles and ovals for leaves.

2. Add a few more leaves at different angles.

3. Draw a stem for each leaf, all joining in the middle.

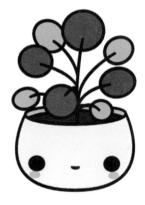

4. Add a squashed oval shape for the top of the pot and a curved line for the rest of the pot.

5. Give the plant pot a cute face and add a curved line near the top for the soil.

6. Color in your pancake plant, adding pink ovals under the eyes for blush.

58. Snake Plant

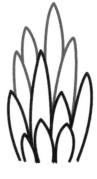

1. Start by drawing three small, pointy leaves.

2. Draw some additional longer leaves behind the first three.

3. Add some more long, pointy leaves on top.

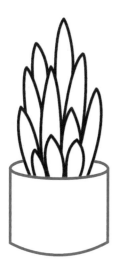

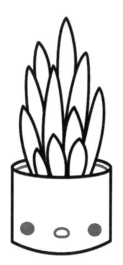

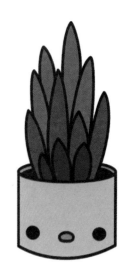

4. Draw a squashed oval for the top of the plant pot, and then draw the rest of the pot.

5. Add a line along the back edge for the soil, and give the plant pot a cute face.

6. Color in your snake plant. You can use different shades of green to add depth.

59. Spider

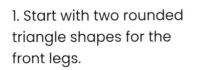

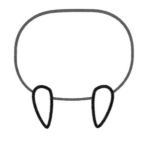

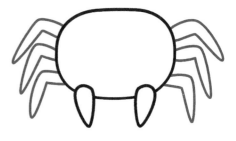

1. Start with two rounded triangle shapes for the front legs.

2. Draw an oval body just behind the two legs.

3. Add three more legs on each side of the body.

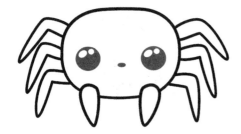

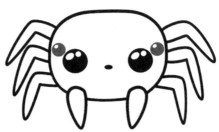

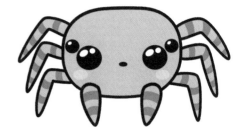

4. Draw two big eyes and a small mouth.

5. Add two more eyes on the sides of the head.

6. Color in your spider, adding pink blush on the face and stripes on the legs.

60. Dragonfly

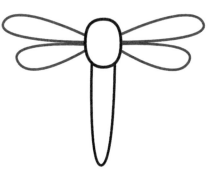

1. Start by drawing a small oval shape for the body.

2. Add a long tail underneath the oval.

3. Draw two long, thin wings on each side of the body.

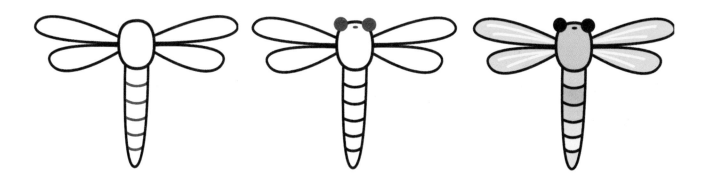

4. Add some curved lines for stripes on the tail.

5. Draw two big eyes and a small mouth on top of the head.

6. Color in your dragonfly, using a light color for veins on the wings.

01. Ladybug

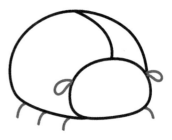

1. Start by drawing a blob shape for the head.

2. Draw a rounded loaf-shaped body behind the head. Add a line on the back where the wings meet.

3. Give the ladybug two feelers and some little lines for legs.

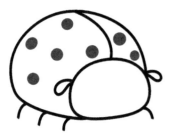

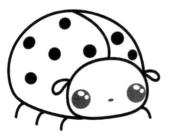

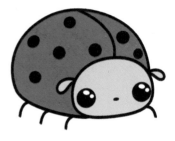

4. Draw some spots on the ladybug's body.

5. Add two big eyes and a small mouth.

6. Color in your ladybug.

62. Caterpillar

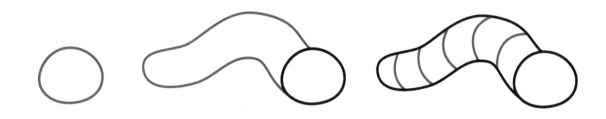

1. Start by drawing a slightly squashed circle for the head.

2. Draw the rest of the caterpillar's body, making it as long as you want.

3. Add curved lines along the body for the segments.

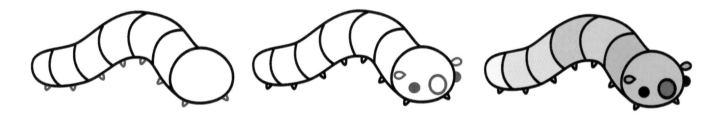

4. Draw some tiny feet along the bottom of the caterpillar.

5. Add two eyes, a big open mouth, and two little feelers on the head.

6. Color in your caterpillar. You can use a different color for each segment to make it interesting!

63. Butterfly

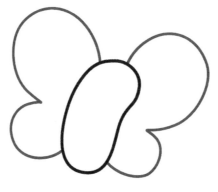

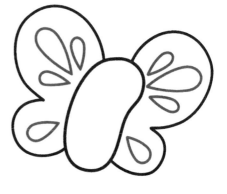

1. Start with a bean shape for the butterfly's body.

2. Draw a big wing on either side of the body.

3. Add some teardrop-shaped details onto the wings.

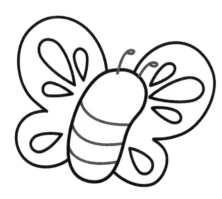

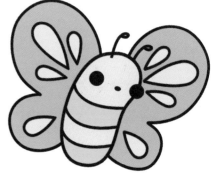

4. Give the butterfly two feelers and some stripes along the body.

5. Draw two eyes and a small mouth on the head.

6. Add whatever colors you'd like to your butterfly.

64. Snail

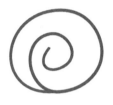

1. Start by drawing a spiral shape for the shell.

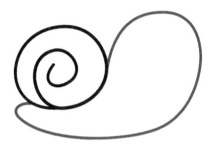

2. Add a big blob shape for the snail's body.

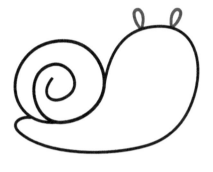

3. Draw two little feelers on top of the snail's head.

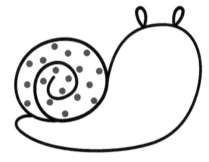

4. Add some polka dots onto the shell.

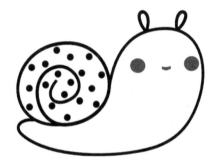

5. Give the snail two eyes and a small smile.

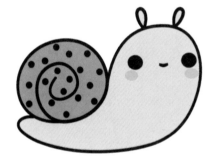

6. Color in your snail, adding light pink blush under the eyes.

65. Leaves

1. Start by drawing three curved lines for the leaf stems.

2. Add some angled lines for the leaf veins.

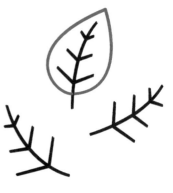

3. Draw a smooth leaf shape around one set of leaf veins.

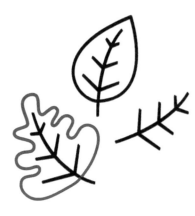

4. For the second leaf, draw a squiggly line around the veins.

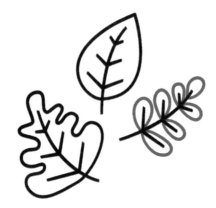

5. Draw some small leaf shapes around all the veins of the third leaf.

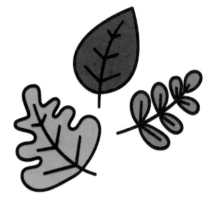

6. Use browns for autumn leaves or greens for a springtime feel.

66. Tiny Forest

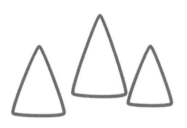

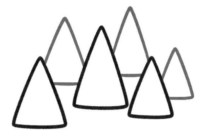

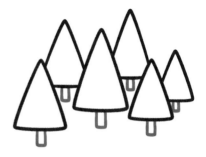

1. Start by drawing three triangles with rounded corners.

2. Draw three more triangles behind the first ones.

3. Give each triangle a small rectangle for a trunk.

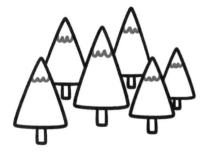

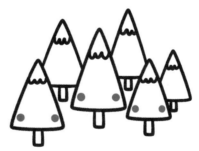

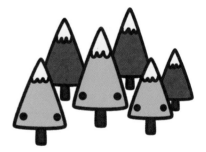

4. Add a squiggly line near the top of each tree.

5. Draw eyes on a few of the trees.

6. Color in your tiny forest, using white on the tops for snow.

67. Mountains

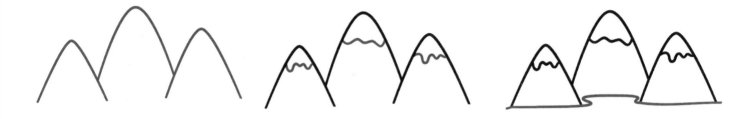

1. Start by drawing three open triangle shapes that overlap slightly.

2. Draw a squiggly line near the top of each mountain.

3. Add a curved line at the base of the mountains.

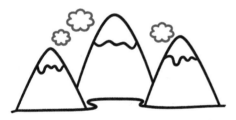

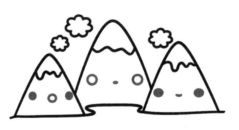

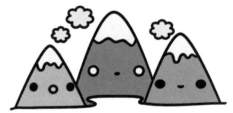

4. Draw some fluffy clouds above the mountains.

5. Give each mountain a face. Try using different facial expressions!

6. Color in your mountains.

68. Shooting Star

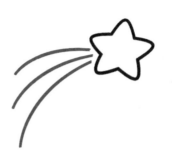

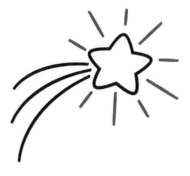

1. Start by drawing a star shape with rounded corners.

2. Draw three long, curved lines on one side of the star for the trail.

3. Add some short, straight lines around the star.

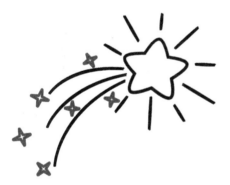

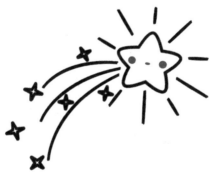

4. Draw a few little sparkles around the trail.

5. Give the star a cute little face.

6. Color in your shooting star.

69. Rainbow & Clouds

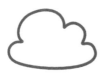

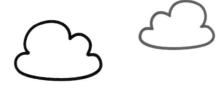

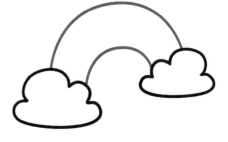

1. Start by drawing a cloud shape.

2. Add another slightly smaller cloud shape next to the first one.

3. Draw two curved lines between the two clouds to create an arch shape.

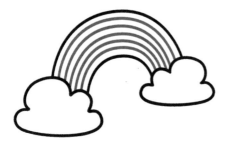

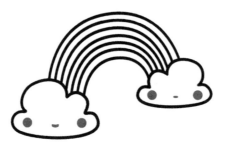

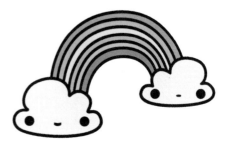

4. Add five more curved lines inside the arch.

5. Give each cloud a cute face.

6. Use red, orange, yellow, green, blue, and purple for the rainbow colors. Then color the clouds with a light pink.

70. Moon & Stars

1. Start by drawing about two thirds of a circle.

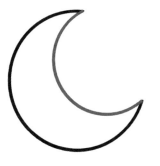

2. Draw a half-circle inside the first circle to form a crescent moon.

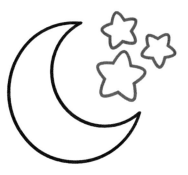

3. Add three little stars next to the moon.

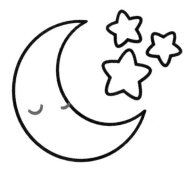

4. Give the moon one sleepy eye and a small mouth.

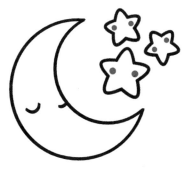

5. Draw two little eyes on each star.

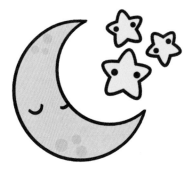

6. Color in your moon and stars, adding some darker spots on the moon for texture.

ANIMALS

71. Fox

1. Start with a blob-shaped head and a small body.

2. Draw a curved line for the tail, with another line near the tip of the tail.

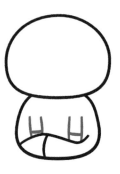

3. Add two legs onto the front of the body.

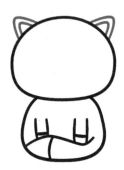

4. Draw two triangle-shaped ears on top of the head.

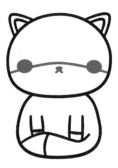

5. Draw a curved line in the middle of the head. Then add two eyes and a nose.

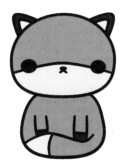

6. Color in your fox! Use white for the face and dark brown for the paws and ears.

72. Squirrel

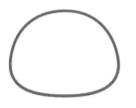

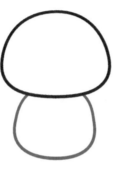

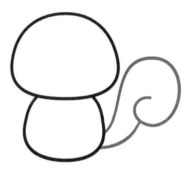

1. Start by drawing a blob-shaped head.

2. Draw a small body under the head.

3. Give the squirrel a big tail with a curved tip.

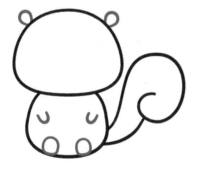

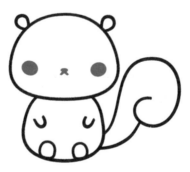

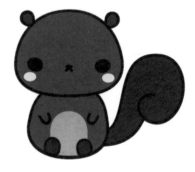

4. Add some ears, hands, and feet.

5. Draw a cute face onto the squirrel's head.

6. Color in your squirrel, giving it a lighter-colored tummy and some pink blush under the eyes.

73. Raccoon

1. Start by drawing a small body and a head with slightly pointy sides.

2. Draw the mask shape in the middle of the head.

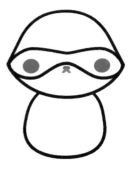

3. Add two big eyes and a tiny mouth and nose.

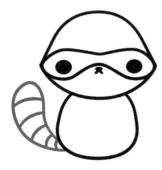

4. Draw a tail with some curved lines for stripes.

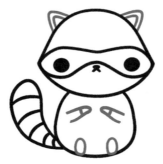

5. Give the raccoon some ears, arms, and feet.

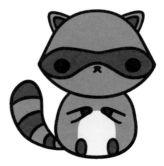

6. Color in your raccoon, adding a dark mask and stripes but a lighter-colored tummy.

74. Bear

1. Start by drawing the bear's body shape.

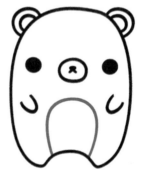

2. Add two eyes and a snout with a small nose.

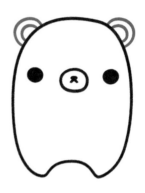

3. Draw two rounded ears on top of the head.

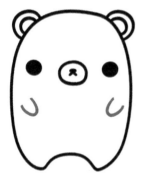

4. Give the bear two little arms.

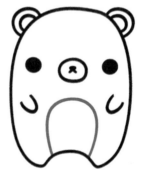

5. Draw a tummy on the front of the bear.

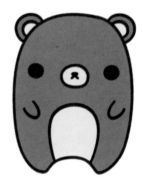

6. Color your bear brown, but use a lighter color for the tummy, snout, and ears.

75. Llama

1. Start by drawing a tall fluffy body shape.

2. Draw a face with a fluffy top and rounded bottom.

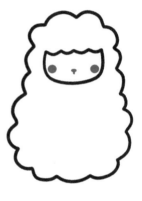

3. Add two circle eyes and a small nose.

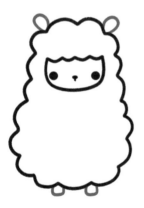

4. Draw two ears on top of the head and two feet on the bottom.

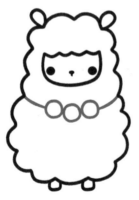

5. Give the llama a cute pom-pom collar.

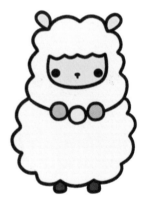

6. Color in your llama.

76. Red Panda

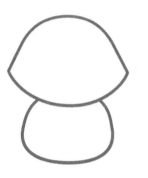

1. Start by drawing a small body and a head with slightly pointy sides.

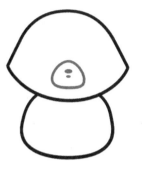

2. Draw a snout with a small mouth and nose.

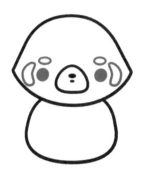

3. Add two eyes, eyebrows, and cheek marks.

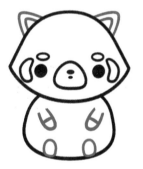

4. Draw two ears, two arms, and two feet.

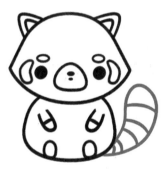

5. Add a tail with some curved lines for the stripes.

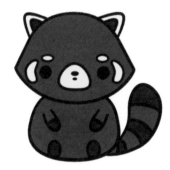

6. Color in your red panda, using a darker color for the tummy, inner ears, paws, and tail stripes.

77. Giant Panda

1. Start by drawing a chubby body shaped a bit like an egg.

2. Add a small snout with a tiny mouth and nose.

3. Draw two eyes and add an oval shape around each.

4. Draw two ears, two arms, and two feet.

5. Add two curved lines over the midsection.

6. Color in your giant panda, using a darker color for the ears, eyes, feet, and the stripe over the tummy.

78. Sloth

1. Start by drawing a chubby body shaped a bit like an egg.

2. Draw two eyes. Then add a thin oval shape around each eye.

3. Add a small mouth and nose in between the eyes.

4. Give the sloth two long arms.

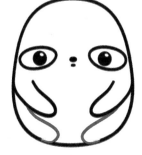

5. Add two long legs underneath the arms.

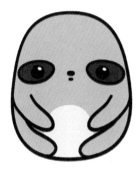

6. Color in your sloth, using a darker color around the eyes and a lighter color on the tummy.

79. Giraffe

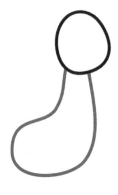

1. Start by drawing a small egg-shaped head.

2. Add a body with a long neck.

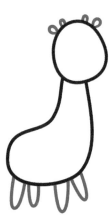

3. Draw four legs, as well as small ears and horns on top of the head.

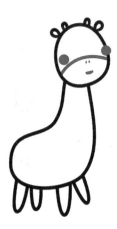

4. Add a curved line for the snout. Then draw the eyes, nostrils, and mouth.

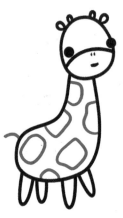

5. Give the giraffe a tiny tail and some large patches on the body.

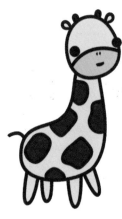

6. Color in your giraffe, using yellow for the body and dark brown for the spots.

80. Lion

1. Start by drawing a blob-shaped head with a big fluffy mane.

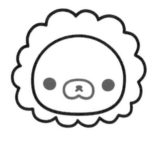

2. Add a snout, nose, mouth, and eyes.

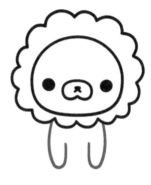

3. Draw two small front legs under the mane.

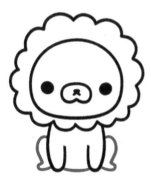

4. Add two back legs and a curved line to complete the body.

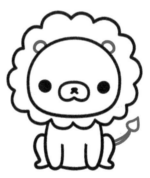

5. Give the lion two ears and a tail with a fluffy tip.

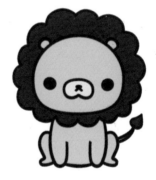

6. Color in your lion, using a darker color for the mane and tip of the tail.

81. Koala

1. Start by drawing a gumdrop-shaped head.

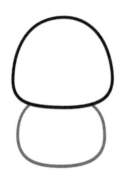

2. Add a round, chubby body under the head.

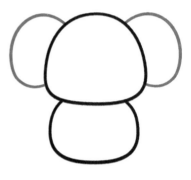

3. Draw a big ear on each side of the head.

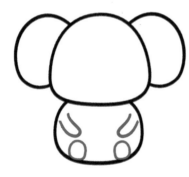

4. Give the koala two long arms and two round feet.

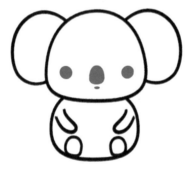

5. Add two eyes, a big nose, and a tiny mouth.

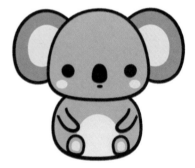

6. Color in your koala with gray, adding a lighter-colored tummy and pink details.

82. Sheep

1. Start by drawing a fluffy cloud shape.

2. Add a face that's rounded at the bottom and fluffy on top.

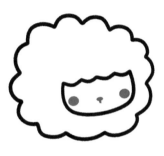

3. Draw two eyes and a small nose.

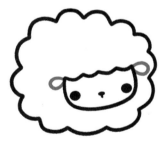

4. Add two ears at the top corners of the face.

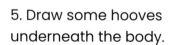

5. Draw some hooves underneath the body.

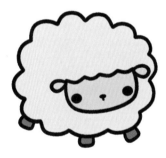

6. Color in your sheep!

83. Cow

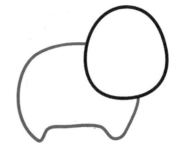

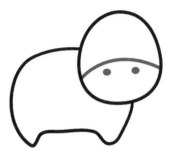

1. Start by drawing a big head shaped a bit like an egg.

2. Add a chubby body with short legs.

3. Draw a curved line for the snout, and add two oval nostrils.

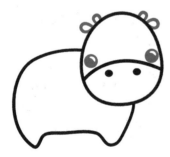

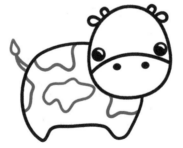

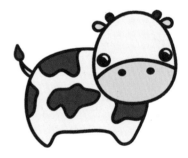

4. Add the eyes, horns, and ears.

5. Give the cow some spots and a little tail.

6. Color in your cow, using a darker color for the spots, horns, and tail tip.

84. Bunny

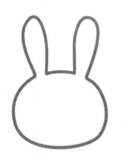

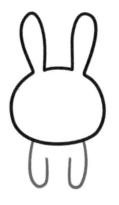

1. Start by drawing a round head with two long ears.

2. Draw two long front legs under the head.

3. Add two back legs. Then draw a curved line along the bottom to complete the body.

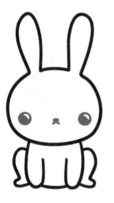

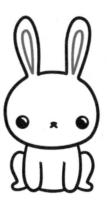

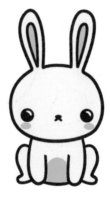

4. Give the bunny two big eyes and a small nose.

5. Draw two smaller ear shapes inside the ears.

6. Color in your bunny, using a light pink for the tummy and blush under the eyes.

85. Bird

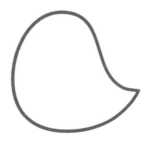

1. Start by drawing a chubby body shape that comes to a point on the right side.

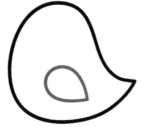
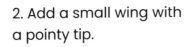

2. Add a small wing with a pointy tip.

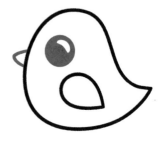

3. Draw a big eye and a tiny beak.

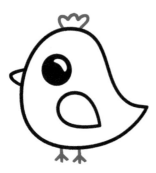

4. Add two little legs and a crown shape on top of the head.

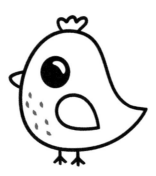

5. Draw some little lines for feathers on the tummy.

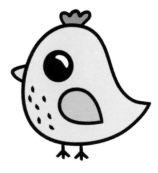

6. Color in your bird using whatever color you'd like.

86. Hedgehog

1. Start by drawing a small bean-shaped body.

2. Add two eyes and a nose.

3. Draw two tiny arms and two little legs.

4. Add the spiky spines on the hedgehog's back.

5. Draw two tiny ears on top of the head.

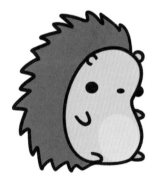

6. Color in your hedgehog with brown, using a lighter color on the tummy.

87. Guinea Pig

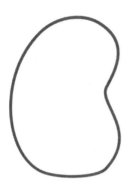

1. Start by drawing a bean-shaped body.

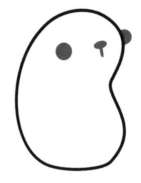

2. Add two big eyes and a nose.

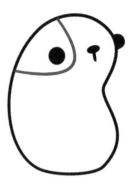

3. Draw a curved line for a patch around one eye.

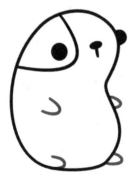

4. Add four little limbs.

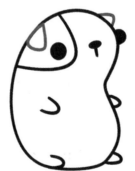

5. Draw two triangular ears on top of the head.

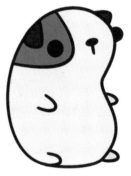

6. Color in your guinea pig, using a darker color for the eye patch and ears.

88. Dog

1. Start by drawing a big, round head.

2. Draw two front legs under the head.

3. Add two back legs and then a curved line to complete the body.

4. Draw a curved line in the middle of the head. Then add two eyes and a nose.

5. Add two triangular ears and oval eyebrows above the eyes.

6. Color in your dog with a Shiba Inu coloring, leaving the eyebrows, the insides of the ears, and the tummy white.

89. Cat

1. Start by drawing a slightly squashed circle for the head.

2. Draw a big, chubby body under the head.

3. Add two eyes, a nose, and whiskers.

4. Draw four little paws on the cat's body.

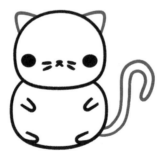

5. Add a long tail and two triangular ears.

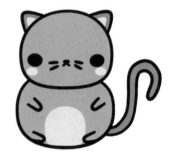

6. Color in your cat, using a lighter color inside the ears and on the tummy.

90. Dumbo Octopus

 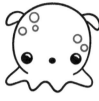 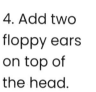

1. Start by drawing a circle with an open bottom.

2. Add tentacles under the circle with a wavy line.

3. Draw two big eyes and a little open mouth on the lower part of the body.

4. Add two floppy ears on top of the head.

5. Draw some little spots on the head.

6. Color in your dumbo octopus.

91. Whale

1. Start by drawing a wavy line with a big, curved line for the whale's body.

2. Draw two flippers on the body.

3. Add another curved line with some stripes along the tummy.

4. Draw two big eyes and a little mouth on the whale's head.

5. Add some water splashes coming out of your whale's blowhole near the top of the head.

6. Color in your whale!

FANTASY CREATURES

92. Mermaid

1. Start with a slightly curved line for the chin. Then add a hairline to frame the face.

2. Use a wavy line to create the rest of the hair. Draw a flower in the hair.

3. Draw two eyes and a little mouth on the face.

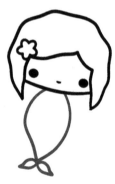

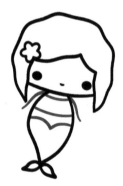

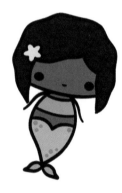

4. Draw the mermaid's body, with two fins at the tip of the tail.

5. Add two arms, a waist, and two curved lines for the mermaid's top.

6. Color in your mermaid, using color to add details on the tail.

93. Fairy

1. Start with a slightly curved line for the chin, and then add a hairline to frame the face.

2. Draw a big, curved line for the rest of the head and hair.

3. Add two eyes and a mouth on the face, and two little circles for hair accessories.

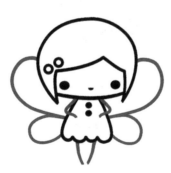

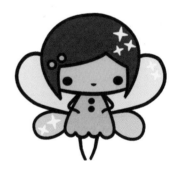

4. Draw the fairy's outfit, with two little buttons at the top.

5. Give the fairy some little arms and legs, and big wings.

6. Color in your fairy, using white to add sparkles on the wings and hair.

94. Alien

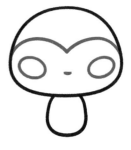

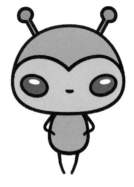

1. Start by drawing a big gumdrop-shaped head.

2. Add a small oval body under the head.

3. Draw a face with two big oval eyes and a small mouth.

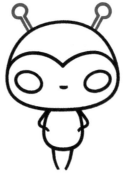

4. Add two arms and two little legs.

5. Draw two antennae on top of the head.

6. Color in your alien, adding white ovals on the eyes to make them look shiny.

95. Yeti

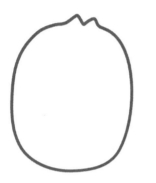

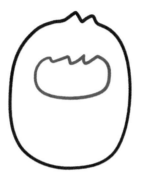

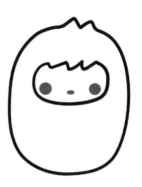

1. Start by drawing an oval body with some fur sticking up on the top.

2. Draw a face with a rounded bottom and furry top.

3. Add two big eyes and a little mouth on the face.

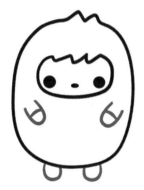

4. Give the yeti two arms and two legs.

5. Draw two horns on top of the head and some fur on the chest.

6. Color in your yeti!

96. Dragon

1. Start by drawing a big head with a small, round body.

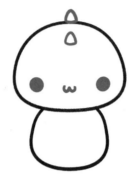

2. Add two eyes, a mouth, and some spikes on the head.

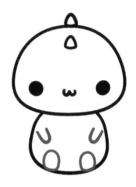

3. Draw two arms and two feet on the body.

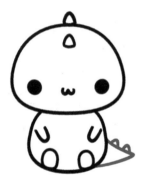

4. Add a pointy tail with some spikes on top.

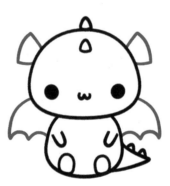

5. Give the dragon wings and fin-shaped ears.

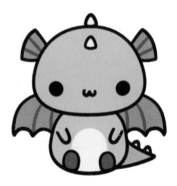

6. Color in your dragon, using a lighter color for the tummy and darker lines on the wings and ears.

97. Griffin

1. Start by drawing a round head with a feathery bottom.

2. Draw two front legs with little claws at the ends.

3. Add the back legs and draw a curved line between the front legs to complete the body.

4. Draw two eyes, a beak, and two triangular ears.

5. Give the griffin two wings and a tail with a fluffy tip.

6. Color in your griffin!

98. Pegasus

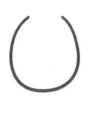

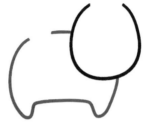

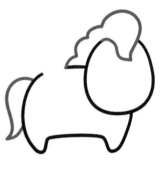

1. Start by drawing an oval head, leaving a gap at the top for the mane.

2. Draw a chubby body and legs. Leave a gap at the top for the wing.

3. Add a fluffy mane on top and a tail at the back.

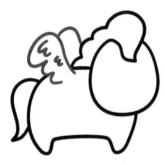

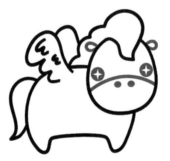

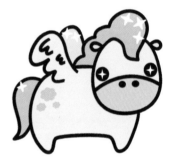

4. Draw a front wing with some squiggles for detail. Then add a curved line for the back wing.

5. Finish the face by adding a snout, sparkly eyes, and tiny ears.

6. Color in your pegasus, using white to add sparkles on the wings, mane, and tail.

99. Centaur

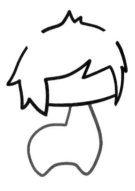

1. Start with a slightly curved line for the chin, and then add a hairline to frame the face.

2. Draw the rest of the hair, leaving two gaps near the top for ears.

3. Add a small centaur body under the head.

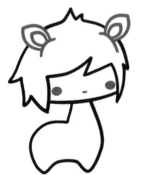

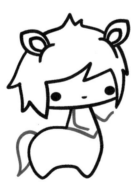

4. Draw two big ears, two eyes, and a small mouth.

5. Add a tail, two arms, and a line at the waist.

6. Color in your centaur, adding some lighter-colored spots on the body.

100. Jackalope

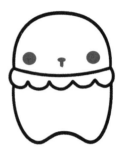

1. Start by drawing a round head with a frill underneath.

2. Add in the rest of the body.

3. Draw two eyes and a little nose.

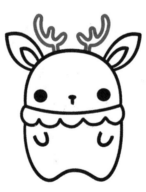

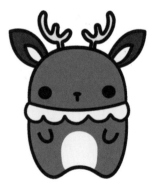

4. Add two big ears and two little hands.

5. Draw two antlers on top of the head.

6. Color in your jackalope, using a lighter color for the tummy.

101. Unicorn

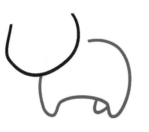

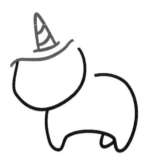

1. Start by drawing the head with a big gap at the top for the mane.

2. Draw the body and legs, leaving another gap near the head for the mane.

3. Add a horn above the head, and two curved lines for part of the mane.

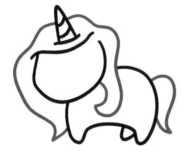

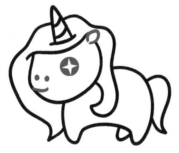

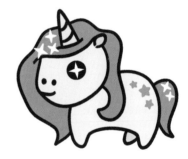

4. Draw the rest of the mane and add a tail at the back.

5. Add the unicorn's ear, eye, nostrils, and mouth.

6. Color in your unicorn, adding some stars on the body and sparkles in the hair.

About the Author

Lauren Bergstrom was born and raised in South Africa and has been doodling cute things since she can remember. When she's not drawing or painting, she spends her time designing crochet patterns for little stuffed animals at mohumohu.com and making video games with her partner at Studio Any Percent. She lives in Canada with her family, in a small home filled with cute and fluffy things.